SIMPLE DRAWING

By John Magic

Hidden Base

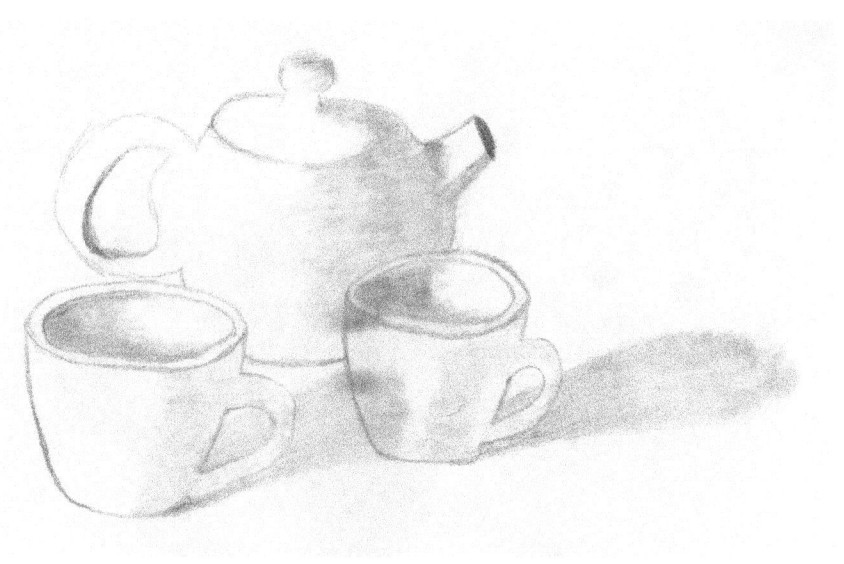

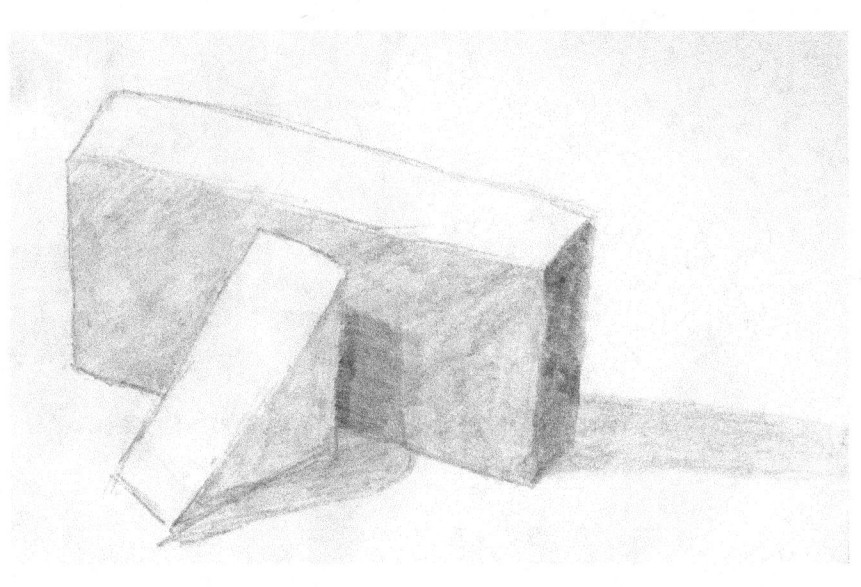

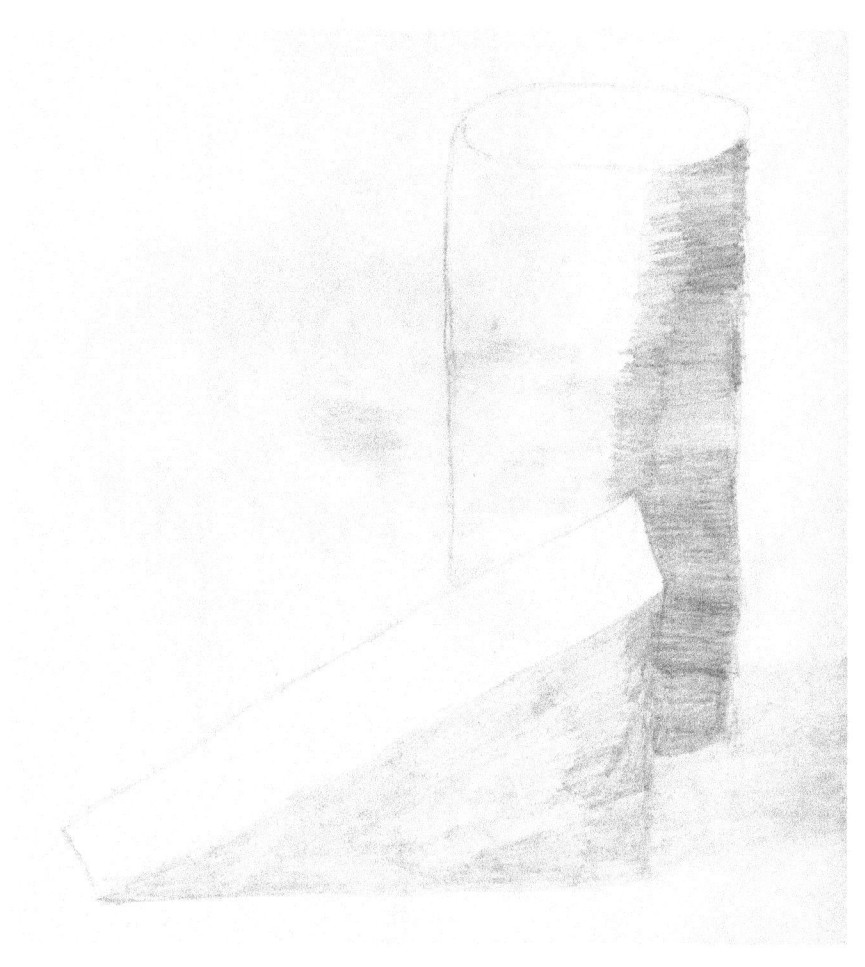

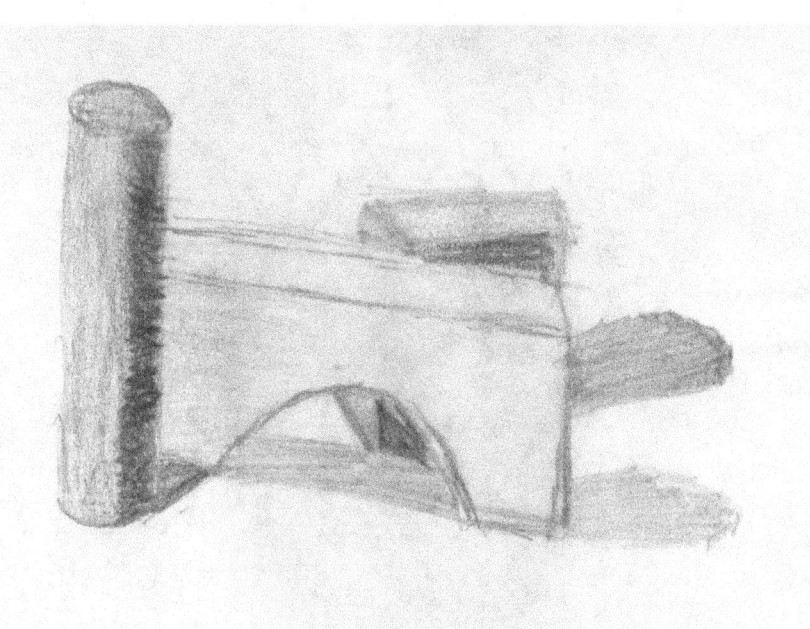

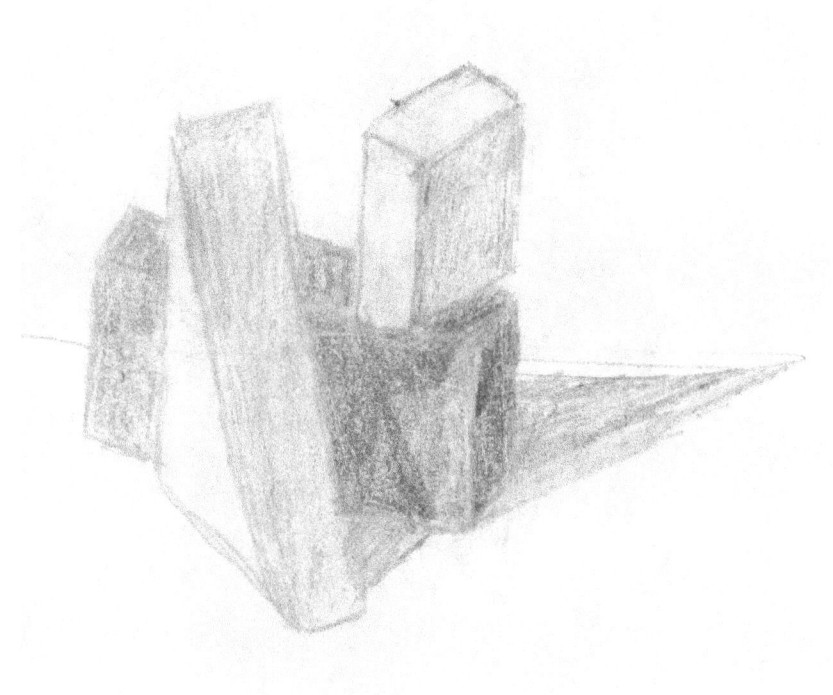

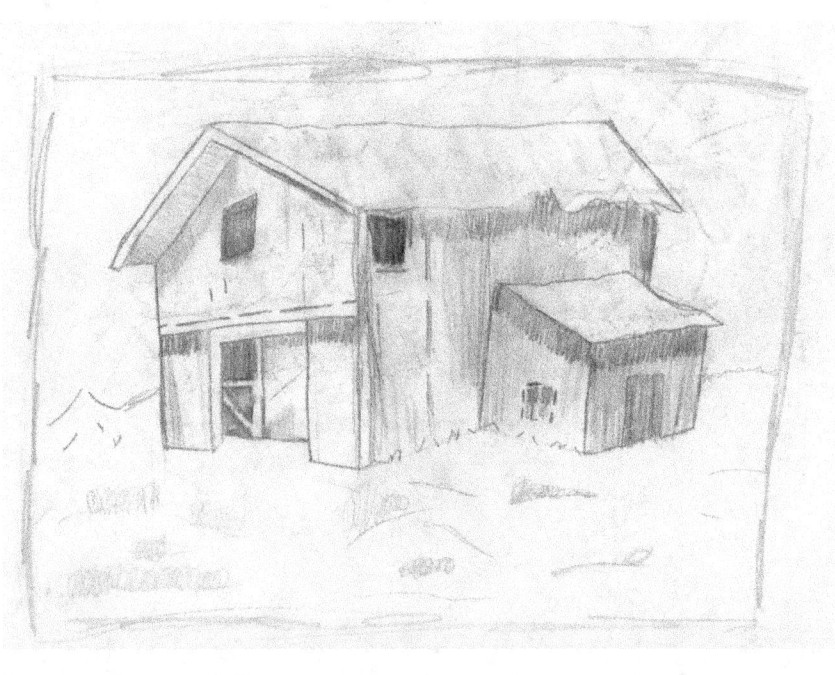

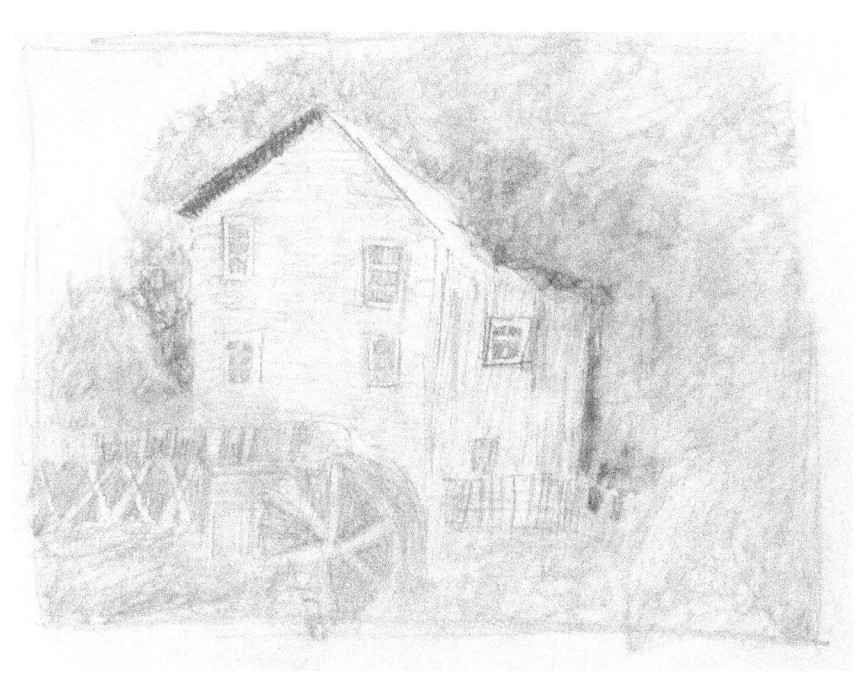

www.ingramcontent.com/pod-product-compliance
Lightning Source LLC
Chambersburg PA
CBHW051322220526
45468CB00004B/1460